D0817640

CHRISTOPHER HART'S
DRAW MANGA NOW!

Chibis, Mascots & More

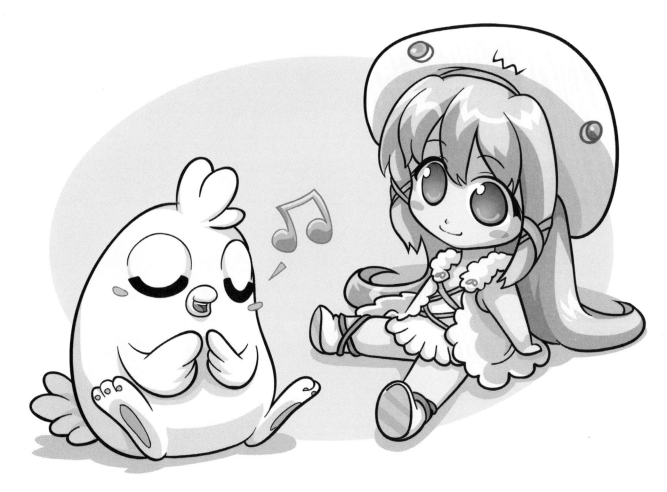

CHRISTOPHER HART'S DRAW MANGA NOW!

Chibis, Mascots & More

Christopher Hart

Watson-Guptill Publications
New York

Compilation copyright © 2013 by Christopher Hart, Cartoon Craft LLC, Star Fire LLC, and Art Studio LLC

All rights reserved.

Published in the United States by Watson-Guptill Publications, an imprint of the Crown Publishing Group, a division of Random House, Inc., New York.

www.crownpublishing.com
www.watsonguptill.com

WATSON-GUPTILL is a registered trademark and the WG and Horse designs are trademarks of Random House, Inc.

This work is based on the following titles by Christopher Hart published by Watson-Guptill Publications, an imprint of the Crown Publishing Group, a division of Random House, Inc.: *Manga Mania Chibi and Furry Characters*, copyright © 2006 by Christopher Hart; and *Manga for the Beginner Chibis*, copyright © 2010 by Star Fire LLC.

Library of Congress Cataloging-in-Publication Data

Hart, Christopher, 1957-
 Christopher Hart's draw manga now!: chibis, mascots, and more / Christopher Hart.-1st ed.
 p. cm.
1.Comic books, strips, etc.—Japan—Technique. 2. Cartooning—Technique. 3. Comic strip characters—Japan. 4. ART / Techniques / Drawing. 5. ART / Studio & Teaching . 6. ART / Techniques / General.
 NC1764.5.J3 H36917 2013
741.5/1
2012042477

ISBN 978-0-385-34546-0
eISBN 978-0-385-34533-0

Cover and book design by Ken Crossland
Printed in the United States of America

10 9 8 7 6 5 4 3 2 1
First Edition

Contents

Introduction

Chibis (pronounced chee-bees) are among the cutest and funniest characters in all of manga. Manga is made up of many genres, but only chibis—those miniature characters with huge personalities—appear in every one of them.

Normal characters turn into a chibi when they have a sudden, giant outburst of emotions, instantly transforming into outrageously cute characters with mini-proportions.

The thing that makes chibis special for manga artists like you and me is that they are not only fun to draw but easy, too! So if you're a beginner, you can pick no better place to start drawing manga characters than with chibis.

Chibis also have pals, or mascots, and you won't want to miss these. They will make your heart melt. They're so fluffy and cute, you just want to squeeze them! These mascots are inseparable from their human chibi counterparts. And guess what? We have a whole section devoted to showing you how to draw them.

Everything you need to create a world of chibis is at your disposal in these pages. You might start off as a beginner, but you'll be on your way drawing cute and funny chibis in no time!

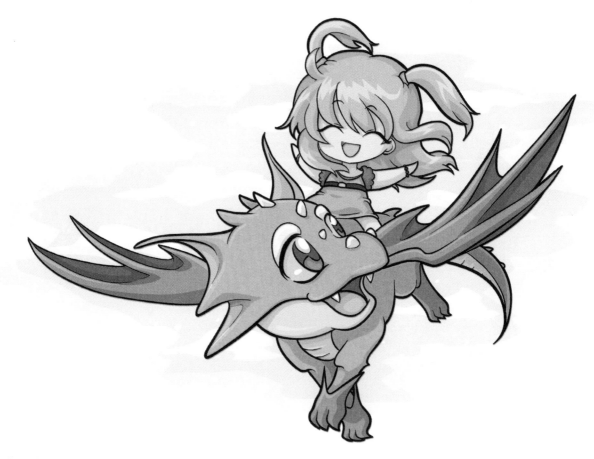

To the Reader

This book may look small, but it's jam-packed with information, artwork, and instruction to help you learn how to draw manga like a master!

We'll start off by going over some of the basics you'll need to know to draw chibi characters, and, of course, their furry mascot friends. Pay close attention; the material we cover here is very important. You might want to practice drawing some of the things in this section, like the bodies, faces, and expressions, on your own.

Next, it'll be time to pick up your pencil and get drawing! Follow along my step-by-step drawings on a separate piece of paper. When you draw the characters in this section, you'll be using everything you learned so far.

Finally, I'll put you to the test! The last section of this book features drawings that are missing some key features. It's your job to finish these drawings, giving characters the eyes, hair, or facial features they need.

This book is all about learning, practicing, and, most importantly, having fun. Don't be afraid to make mistakes, because let's face it: every artist does at some point. Also, the examples and step-by-steps in this book are meant to be guides. Feel free to elaborate and embellish them as you wish. Before you know it, you'll be a manga artist in your own right!

Let's begin!

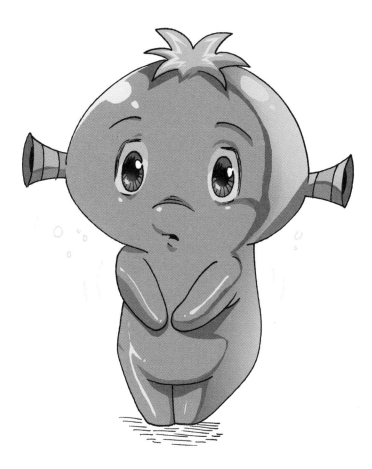

PART ONE
Let's Learn It

Chibi Basics

You can't just shrink a regular-sized person down to the size of a chibi; it wouldn't work. Chibis have a very specific look. In this part, I will introduce you to some of the basic proportions and characteristics of a chibi. You'll see what makes a chibi character different from regular manga characters—from the obvious size difference to more specific features.

What Makes a Chibi a Chibi?

All chibis have particular traits in common. Once we recognize these traits, we can create these adorable, high-energy characters.

When you think of chibis, think of four things: Think big, think simple, think round, and think chunky.

1. Think big, because chibi heads are much bigger in relation to the size of their bodies than the standard manga character's head. While a normal-size person is six to seven heads tall, chibis are only two to three heads tall. Their heads look huge on their tiny, little bodies.
2. Think simple, because things that are simple are cute.
3. Think round, because the rounder something is, the younger it looks. Plus people respond positively to round shapes.
4. And, finally, think chunky, because chibis are never skinny, but tend to be slightly chubby (or at least, have a little tummy, which gives them that sweet, innocent look that is so cute).

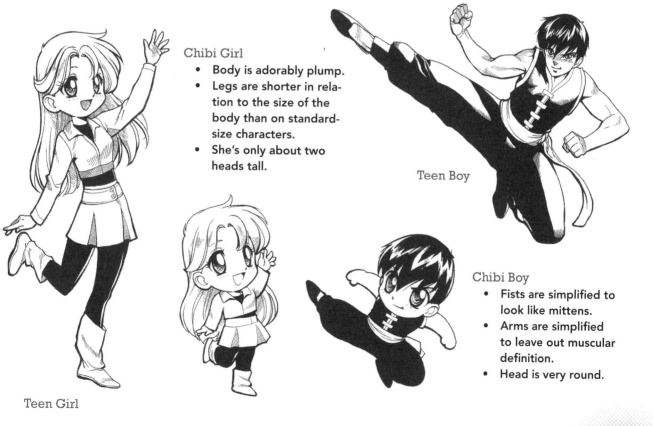

Chibi Girl
- Body is adorably plump.
- Legs are shorter in relation to the size of the body than on standard-size characters.
- She's only about two heads tall.

Teen Boy

Teen Girl

Chibi Boy
- Fists are simplified to look like mittens.
- Arms are simplified to leave out muscular definition.
- Head is very round.

The Chibi Face

Chibis have the easiest faces to draw in manga, because their features are so basic. The noses are dots, and the mouths are simple. But the eyes take a bit of work—and fill up most of the face. However, if you're willing to put in just a little bit of effort, you'll come up with adorable results!

The eyes, like all of the features, are always placed low on the face. That's because chibis are depicted as youthful mini-people, even in the instances where they are adult characters, and eyes are always placed low on youngsters. Their faces are also very round.

Key Features of a Chibi Face

We've already discussed how chibi heads are proportionately larger in relation to their bodies than standard-size manga characters' heads. Now, let's take it a step further and identify the specific features of the face that make chibis different from standard manga characters.

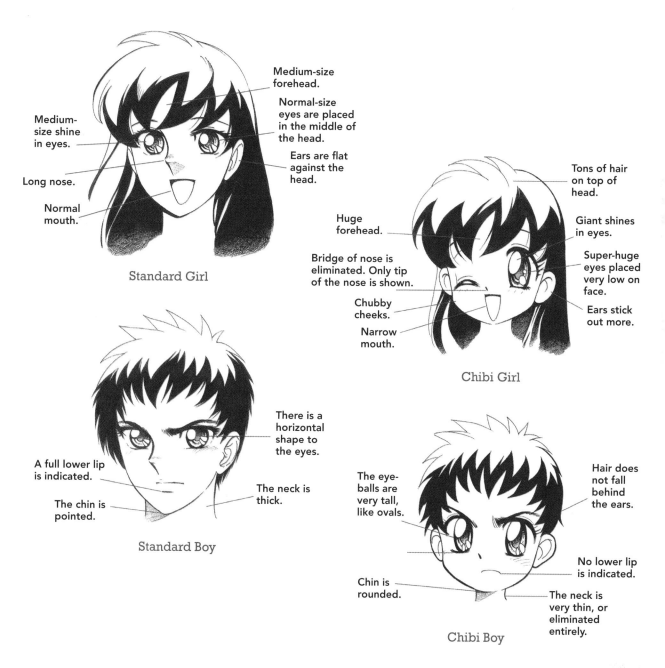

Medium-size forehead.

Normal-size eyes are placed in the middle of the head.

Ears are flat against the head.

Medium-size shine in eyes.

Long nose.

Normal mouth.

Standard Girl

Tons of hair on top of head.

Giant shines in eyes.

Super-huge eyes placed very low on face.

Huge forehead.

Bridge of nose is eliminated. Only tip of the nose is shown.

Chubby cheeks.

Narrow mouth.

Ears stick out more.

Chibi Girl

There is a horizontal shape to the eyes.

A full lower lip is indicated.

The chin is pointed.

The neck is thick.

Standard Boy

Hair does not fall behind the ears.

The eyeballs are very tall, like ovals.

No lower lip is indicated.

Chin is rounded.

The neck is very thin, or eliminated entirely.

Chibi Boy

Chibi Girl Face

I know you're tempted to start off with those great big eyes, but it works best to begin with the outline of the face before you start on the features. Sketch the center line and the eye line to divide up the face evenly. The ears will be at the same height as the eyes.

Giant eyes.

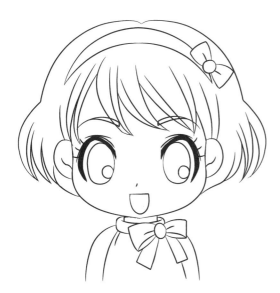

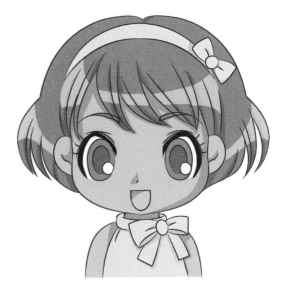

Chibi Boy Face

Boys' and girls' head shapes are the same—it's the eyes (no eyelashes here) and hairstyles that are different (plus, the boys' eyebrows are a bit thicker).

Note the standard chibi hallmarks again: the huge eyes set low and wide on the head, the mouth set even lower, the hair flopping down over the forehead, and the hardly noticeable neck.

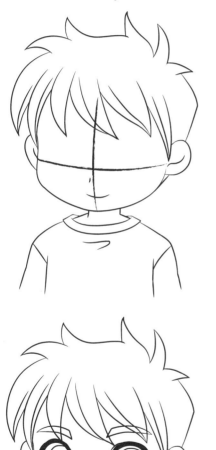

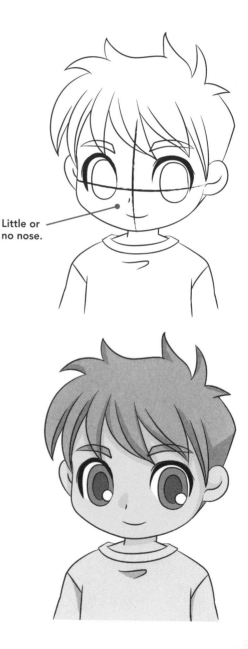

Little or no nose.

Big head on skinny neck.

The Chibi Body

Now we'll practice drawing chibi bodies in the poses commonly seen in manga. We'll begin with the front, 3/4, and side views. Since chibis are so round and short, drawing bodies has never been simpler to tackle! Remember, the torso of a chibi is one basic shape and all chibis have heads that are very large compared to their bodies. Keep everything very round and plump.

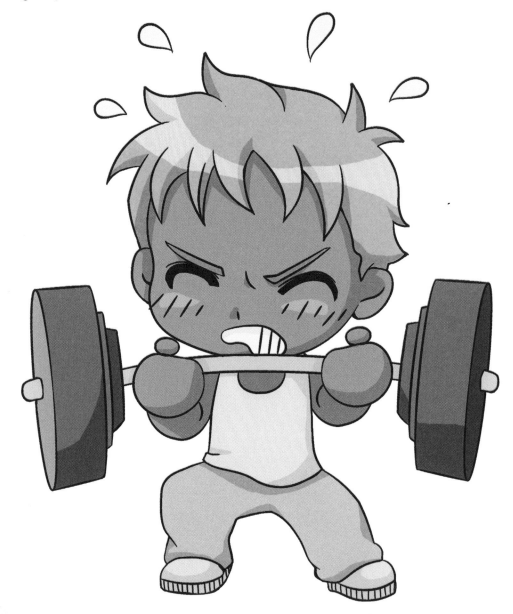

Chibi Proportions

Chibis typically have giant heads on small, childlike bodies and round little hands and feet. The most popular proportion for drawing chibis is about three head lengths tall. That means that if you were to stack three chibi heads on top of each other they would equal the chibi character's total height.

However, three heads is by no means the only chibi proportion that works. Some chibis are just two heads tall and excruciatingly adorable! Other, even more exaggerated, chibis have heads that are twice as big as their bodies. You can draw your chibi any size you want; however, when you start to make them taller than three heads, they begin to look less like chibis.

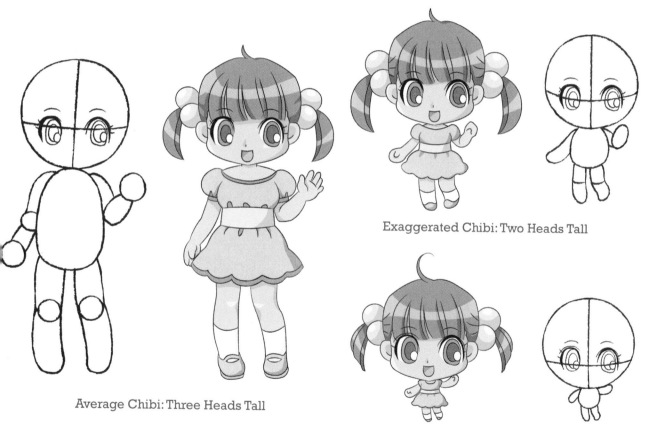

Average Chibi: Three Heads Tall

Exaggerated Chibi: Two Heads Tall

Tiny Chibi: Head Twice as Tall as Body!

Chibi Girl Front View

You've already noticed just how tall the chibi head is compared to the height of the body. But pay attention to just how wide the head is, too. It's much wider than the entire body—and that's what makes it so darn cute! This chibi's eyes are spaced far apart, making full use of the considerable width of her head. And just one note about her legs: chibis never have long legs; theirs are always short and thick. Sometimes, the legs get widest at the bottom, toward the feet. That's a stylistic choice.

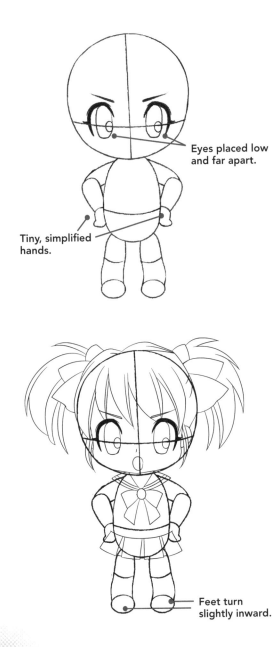

Eyes placed low and far apart.

Tiny, simplified hands.

Feet turn slightly inward.

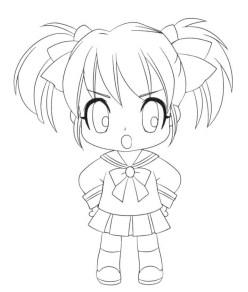

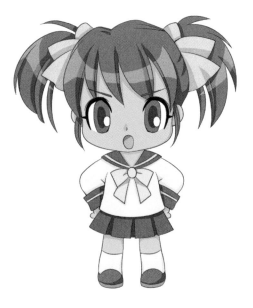

Chibi Boy Front View

The boy chibi body has the same basic construction as the girl character, but his shoulders and arms are a bit more built up. Still, he's no bodybuilder! The main differences between him and the girl are his costume and hairstyle. So if you can draw a girl chibi, you can draw a boy chibi, too!

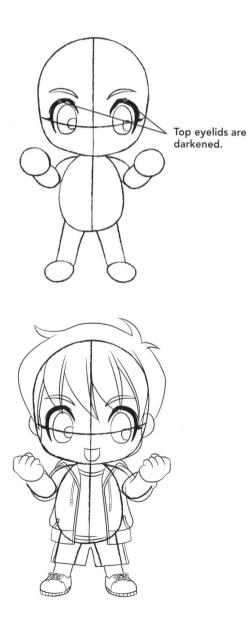

Top eyelids are darkened.

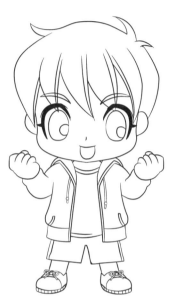

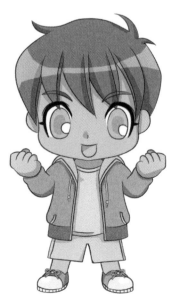

3/4 View Girl

This is a natural angle, and is used very often. It takes a little getting used to for the artist, however, because a little bit of perspective is involved. But once you get the hang of it, you'll always be able to do it.

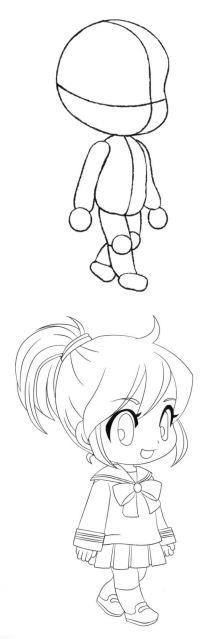

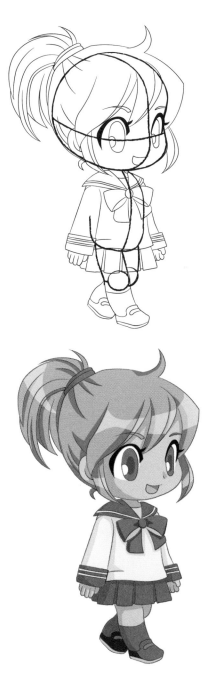

3/4 View Boy

To make the character look round in the 3/4 view, draw an ear on the other side of the head as well as the far arm. Some beginning artists leave these out, and the result can look flat. Remember, the chibi head is enormous! It looks best to cover it with hair that brushes over the eyebrows either in bangs or raked to the side.

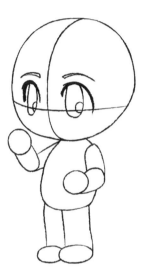

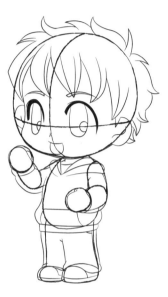

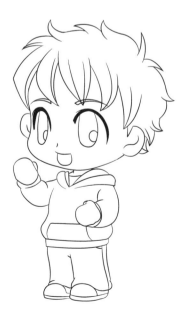

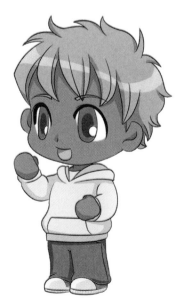

Side View

While you can hide the rear leg behind the front one in a side view of the body, I wouldn't recommend it. This would make the character look stiff and immobile, like a statue. To avoid this, simply bend one of the knees so that we see two legs. Raising one of the arms from the body also makes this pose more lively.

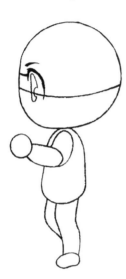

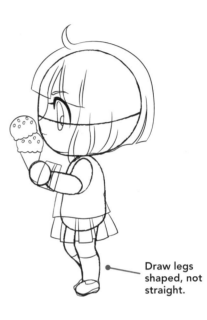

Draw legs shaped, not straight.

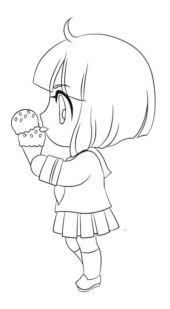

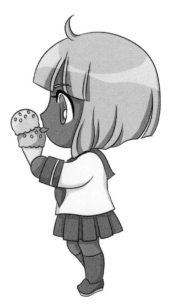

Different Views of the Chibi Body

Here's a little summary of all the different views of a chibi body. Use this as a reference guide when you need it. You'll probably find yourself drawing characters in the front view and 3/4 view most often, but the side view and rear views will come in handy, as well.

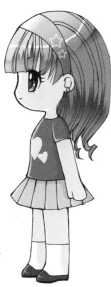 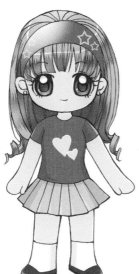 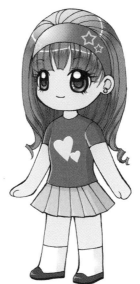 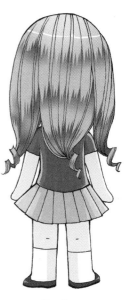

| Side | Front | 3/4 | Back |

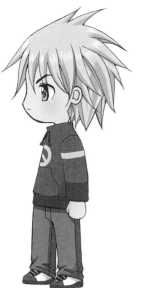 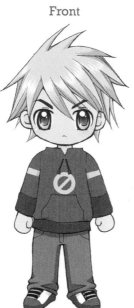 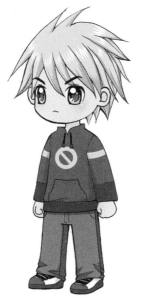 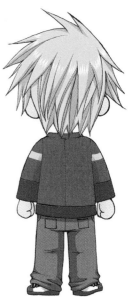

Chibi Facial Expressions

A chibi's emotions are easy to read—just look at their facial expressions. Some chibis are happy, others are grumpy, and some are furious! Just because they're small doesn't mean that they don't have BIG expressions, or even bigger reactions. In fact, chibi expressions are so over-the-top that they are downright hilarious! They react on a much, much bigger scale than regular full-sized characters. It's funny to see huge emotions coming from such tiny characters!

Let's compare the standard expressions of regular-size manga characters with their chibi counterparts. You'll see that the chibi face is distorted and elastic—stretching way beyond what's normal. The key to chibi expressions is to make them big, broad, and highly exaggerated.

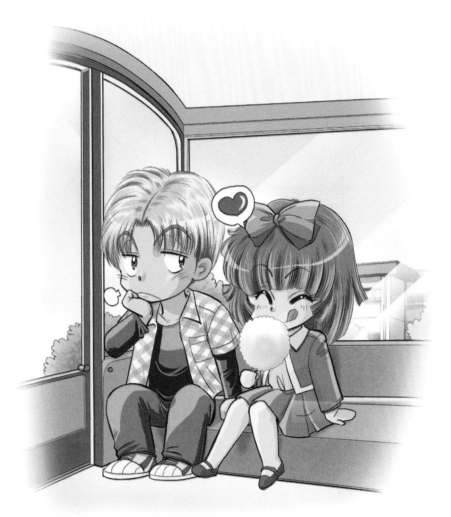

Happy

Standard Manga

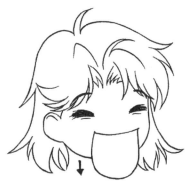

Chibi
The chibi's mouth falls below the line of the chin.

Pucker Up

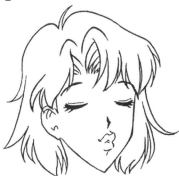

Standard Manga

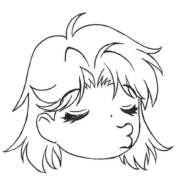

Chibi
When puckering, the chibi lips suddenly get huge.

Silly

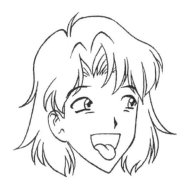

Standard Manga

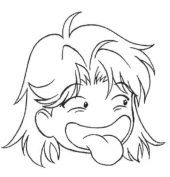

Chibi
The chibi mouth gets big and the tongue gets even bigger!

23

Angry

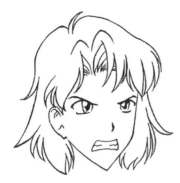

Standard Manga

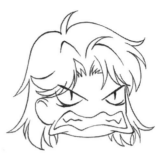

Chibi
The angry face stretches wide. The pupils get teeny and catlike.

Boo-Hoo!

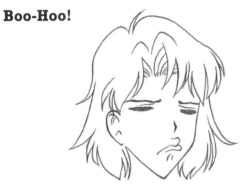

Standard Manga

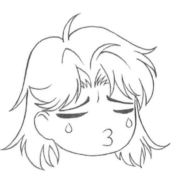

Chibi
Add some tears, and give her a very pouty mouth.

Furious

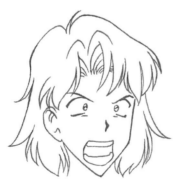

Standard Manga

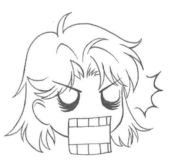

Chibi
Tremendous dark circles suddenly appear under the eyes, which in turn grow white with rage. Teeth show, and the mouth drops below the face.

Annoyed

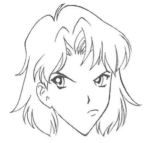

Standard Manga

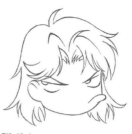

Chibi
The mouth pushes way over to one side. The pupils become little white half-circles.

Tired

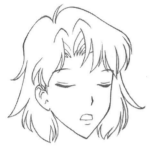

Standard Manga

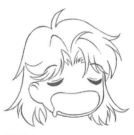

Chibi
Don't forget the all-important drool!

Yucky!

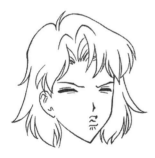

Standard Manga

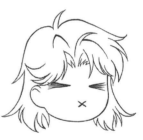

Chibi
An "X" for a mouth gives her that "sour lemon" face.

Self-Confident

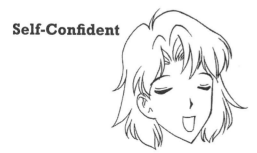

Standard Manga

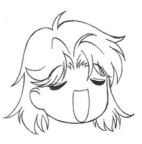

Chibi
A super-tall mouth gives her an air of satisfaction.

Body Language

Body language and funny poses not only get laughs, but also help to clarify a character's expression. Because chibi bodies are adorable, make them part of the act! Just as a chibi's big reaction can be seen in the face, their bodies convey a lot of emotion and energy, too.

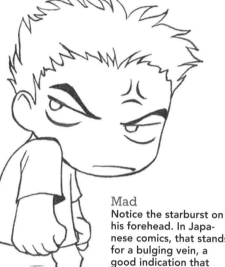

Mad
Notice the starburst on his forehead. In Japanese comics, that stands for a bulging vein, a good indication that someone is really mad.

Pull!
This character leans back, and grits her teeth. This pose won't work if it doesn't have that "lean," no matter how many sweat marks you put around her.

Bright Idea!
A snap of the fingers, one hand on the hips, a wink and a smile—now that's a brain cooking up a good thought!

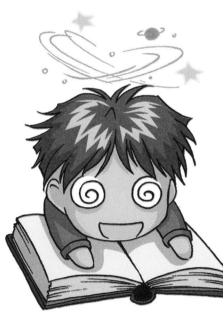

Dizzy
Dizzy characters are drawn with spirals in their eyes, and a swirling bunch of mini-stars and planets overhead. This chibi is so dizzy he leans forward, collapsing.

My Crush!
Multiple stars in the eyes indicate wishful thinking.

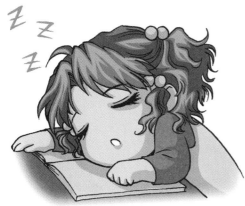

Sleepy
Add the letter "Z" a bunch of times. Her mouth should form a little "O."

Uh, Oh!
In fear, the chibi body freezes, with the arms extended. Notice the extra-wide mouth, pulled way low on the face.

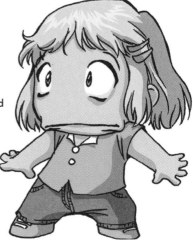

Hilarious
Note how the laughter lines fan out around the character's head. The head of a laughing character always tilts up. He hugs his belly, which hurts from laughing so hard.

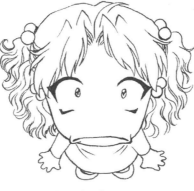

Shocked
Here the eyes go wide, but the pupils become small beads. Drop the mouth way down low on the face.

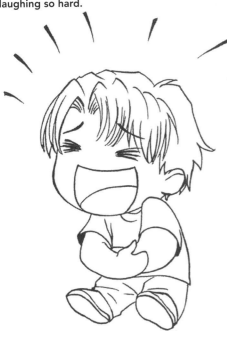

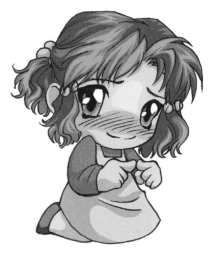

Blushing
Sketch blush lines going across the face. The body language should be introverted, with hands close together, as if the chibi is nervous.

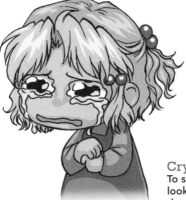

Crying
To show a chibi crying, draw eyes that look wobbly, with tears streaming down the cheeks.

Mascots and Monsters

These cuddly little creatures are chibis' pals. Mascots hop along for the ride, going everywhere with their chibi. There is no finer friend than a tiny manga mascot. Now, let's learn how to draw them!

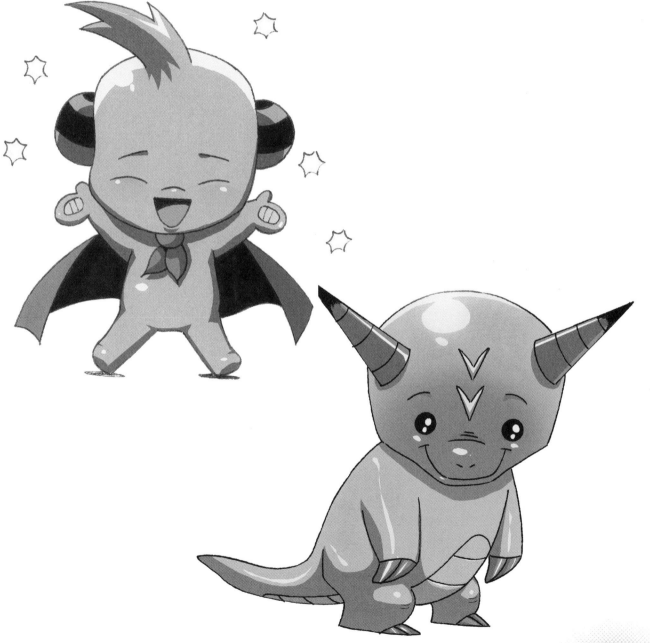

Creating Mascots from Basic Shapes

Let's start with the basics and then work our way up to more challenging mascots. The first step in drawing a chibi's pal is to begin with simple shapes.

Any shape can serve as the foundation for a chibi mascot. Here, we'll try using a triangle. First, section off the corners of the triangle. Next, decide where to place the eyes. Add additional triangles to the outline of the figure to create the arms. Now soften the outline of the figure so that it doesn't look as if it were drawn with a ruler. Add stripes, markings, a mouth, and embellish the eyes.

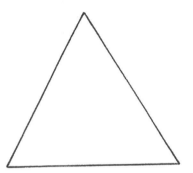

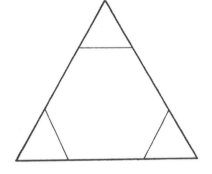

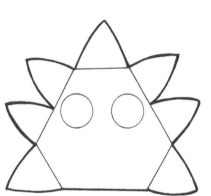

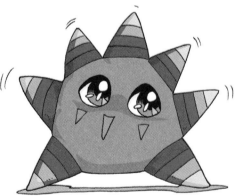

Eye Placement

The placement of the eyes helps determine the look of the character. The wider apart they are, the cuter the character. The closer together they are, the goofier the character.

Eyes up high and together = silly.

Eyes in the middle = cute.

Eyes down low and wide apart = strange looking.

Gallery of Mascots

The basis for all of these little manga mascots is animals. That's right, cute little animals. And if you want to make them extra cute: baby animals. All you have to do is create a cartoon of the animal with some manga features and styling.

While regular manga animals are drawn somewhat realistically, chibi mascots are fanciful, and can be altered in whimsical ways to make them unusual-looking and fun. Chibi mascots often have special talents and powers, which you can build into the character design. If you want your mascot to be more attention-grabbing, begin with an unusual animal. Choose an animal that people don't see every day; in other words, no pets or farm critters.

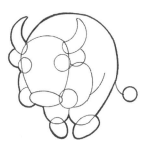 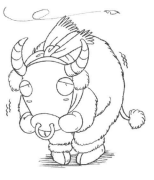 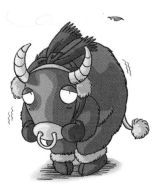

Buffalo
A buffalo is a shag carpet with hooves. Therefore, creating a chilly buffalo is a funny idea.

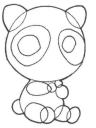 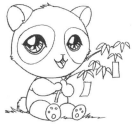 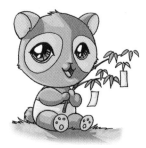

Panda
If he were any sweeter, I think I'd need a dentist.

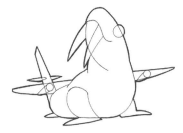 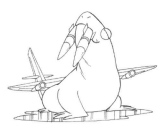 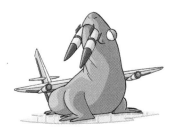

Walrus Missile Launcher
Flossing must be done very, very carefully.

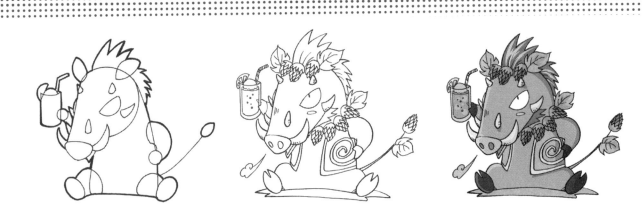

Warthog

A glass of soda, a loud outfit, and he looks like an ill-mannered tourist with tusks!

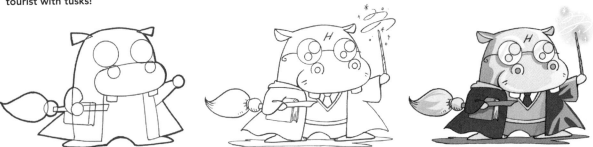

Hippo Magician

Perhaps this one is a professor of magic. He's got all the appropriate props: professional glasses, a wand, a book of magic, and a broomstick. The tie, vest, and long coat give him the look of academia.

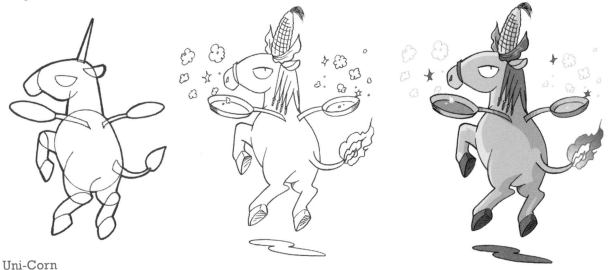

Uni-Corn

Get it—"corn"? You know, he's popping his own corn, and, er . . . ah well . . . never mind.

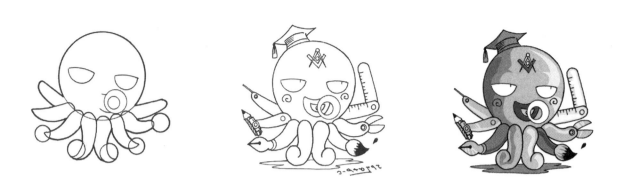

Octopus Genius

An octopus is reported to be one of the smartest creatures of the sea. So we've taken that idea a step further. This overachieving little student is busy learning all about algebra, geometry, and calculus, as well as how to suck the vital organs out of smaller fish.

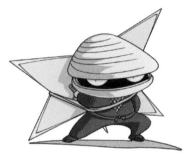

Martial Arts Master Clam

A ninja clam? Yes, my friend, and it's the only mollusk that is feared by the U.S. military.

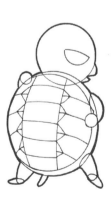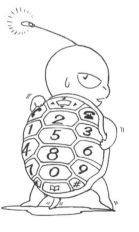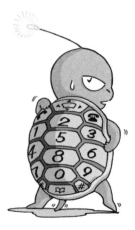

Turtle-Phone

By melding technology with an animal character, you come up with a turtle who can call out for pizza! Too bad he can't quite reach his own keypad!

Mini-Monsters

Some of the most inventive mascots are found in the realm of the cute mini-monsters. This is where your imagination becomes your primary tool. As you get creative in coming up with various types of creatures, try to maintain chibi proportions, which for the most part are based on simplified shapes and chubby little bodies. Although many adorable manga monsters come solely from the imagination, many are also based on dinosaurs, mammals, birds, and even sea life. Some are a little evil, but even the evil ones are never drawn to appear overly serious. Keep it witty and fun!

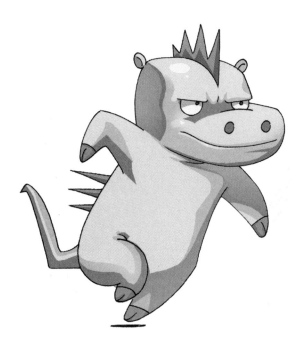

Spiky Hippo
As you've no doubt noticed, many chibi mini-monsters stand upright on two legs, like humans. The eyes of these monsters should be adjusted to be manga-style. Add some embellishments like a long, "unhippolike" tail, spikes on the back, and dorsal fins on the head.

Boxing Dinosaur
No group of chibi mini-monsters would be complete without at least one superpowered, predatory dinosaur. They terrify the smaller chibi monsters, but they're funny because they're such tiny bullies. The T. rex was known to have puny, useless arms. So what are a couple of boxing gloves going to do for him?

Anxious Monster

Some monsters are worriers. They make you want to just pick them up and reassure them. Sometimes the little monster can be a pain in the neck—too needy, or too curious at the wrong times, but always adorable.

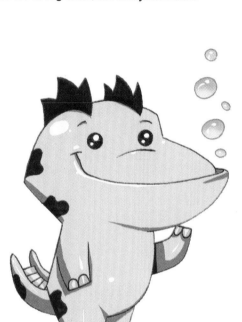

Burping Gator

You've got to excuse him. He forgets his manners whenever he gets a little tummy trouble. He has a unique double set of dorsal fins on top of his head and a double set of tails fused together. Irregular spots decorate his chubby body. Make sure that the back of his head sticks out from his body, in the same way that his jaw sticks out.

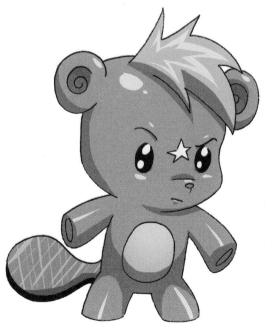

Spunky Plushy

Many of the most beloved mini-monsters look like children's plush toys. The trick is to make them look determined and ready to pounce while still being squeezable and cute. The limbs at the hands and feet get wider, as they often do on teddy bears. However, a huge tuft of spiked hair brings him into the manga genre. And notice the little star on his forehead: Facial emblems and markings are common. Last, the tail is from a completely different animal: the beaver.

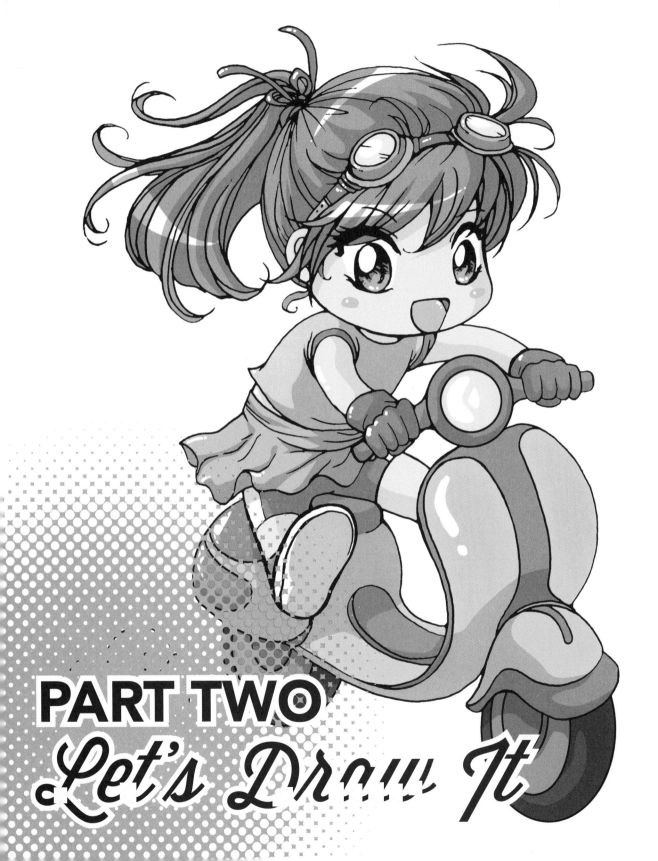

PART TWO
Let's Draw It

Honors Student

Note that this superachiever is made to look studious because of two props: her book and her glasses. Without them, she'd appear to be an average girl. She is drawn in the ¾ view we covered earlier. Her torso is egg-shaped, and her hands are round, with no definition of fingers.

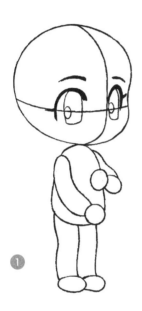

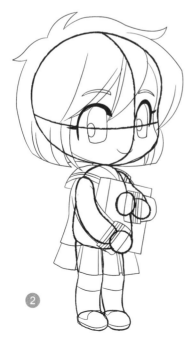

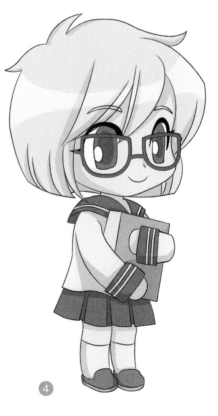

Walking to School

Again, to make a character look three-dimensional, indicate the far ear on the other side of his head, as well as the far arm and, in this case, a little bit of the heel of the far foot as it rises up off the ground.

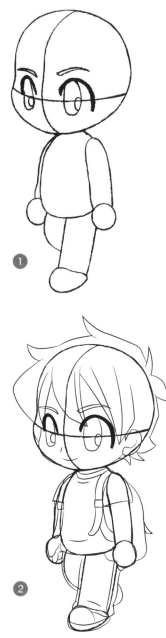

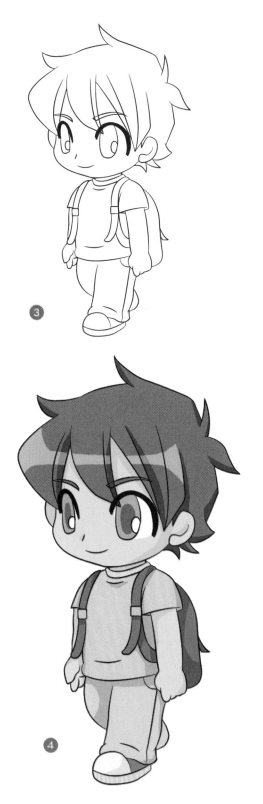

Bear Buddies

There isn't too much you need to change on a
chibi girl to make her a bear-girl. Besides bear ears
and a tiny tuft of a bear tail, what are we going to
give her to reinforce her new identity? Well, how
about a humongous teddy bear to lug around
with her wherever she goes? Draw the two of them
cheek to cheek, to show affection. Only a chibi is
as small as her toys!

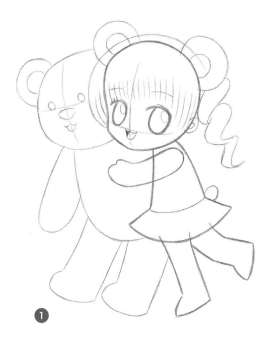

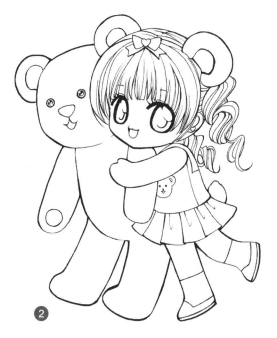

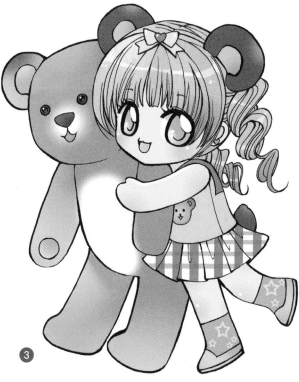

Silly Songbird

This little bird loves music. Note the scale of the mascot as compared to the chibi. This is a typical, medium-size chibi mascot. The mascot has a big tummy that curves in, and big eyelashes, too. His chibi friend, by contrast, has a tiny nose and mouth. Her hat is gigantic, making this a funny scene.

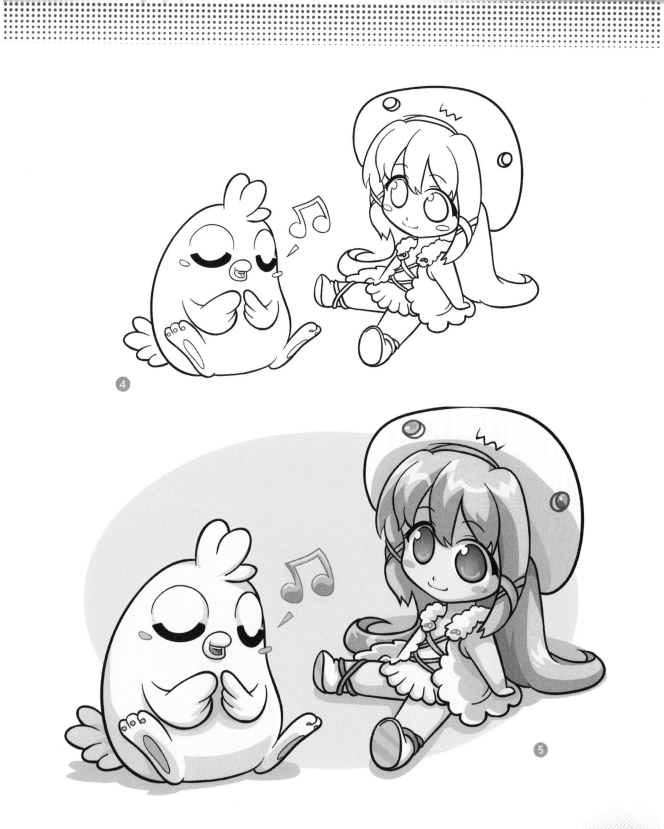

Flying Companion

Trying to keep up with a small flying mascot will
have you out of breath in no time! These little
companions flit about playfully, having fun with
their human pals. This mascot is built on as basic
a shape as you can have: the circle. The giant eyes
and split lip give it a cute, animal-like face. The
squiggly things and tail give it a fantasy look.

Note the pose of the human chibi. The extended
foot is planted at an angle, instead of straight down,
in order to show action. The arms and elbows are
out from the sides of the body. And the hair, too,
bounces around, adding to the sense of motion.

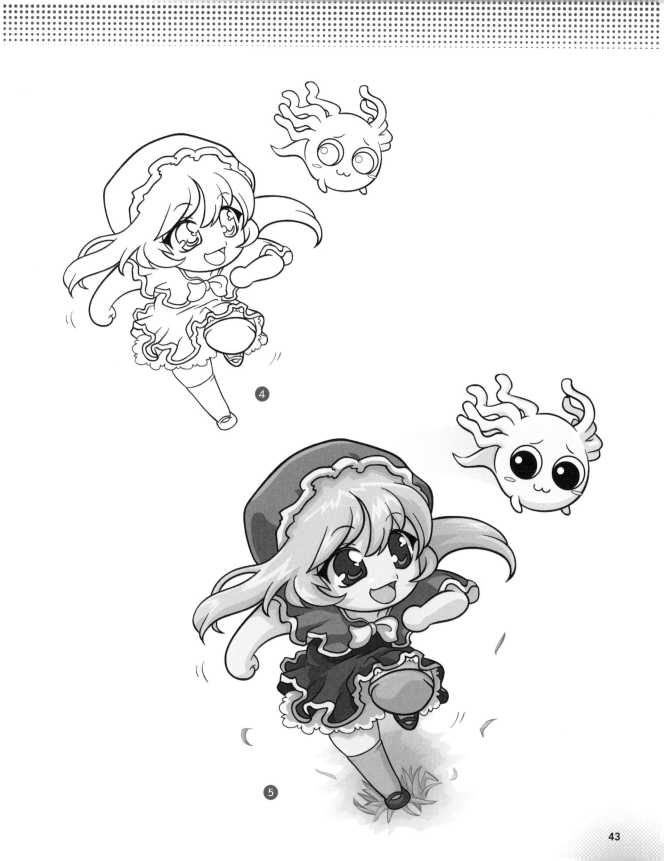

Dragon Friends

Mini-monsters provide the ultimate wish-fulfillment fantasy: the ability to fly. Winged monsters need a wingspan wide enough to give the illusion of good gliding capabilities. Therefore, drawings of these characters will be more horizontal, since the wings stretch out across the page.

It works best to draw the monster first; this gives you a platform on which to draw the sitting girl. Keep her body simple.

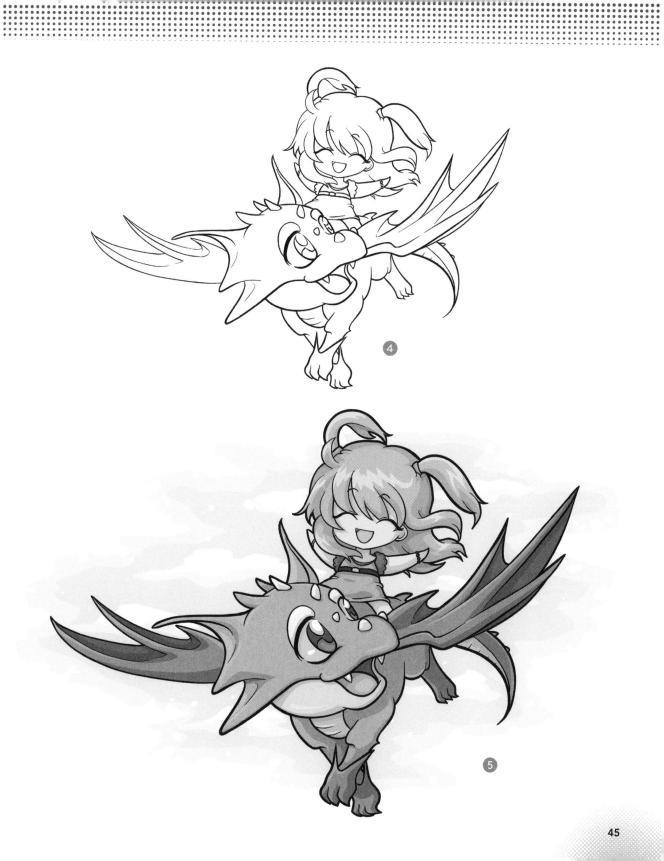

Hyperactive Fur Ball

The tinier they are, the faster they bop around! It's no use trying to calm down these playful little creatures. They are a bundle of energy and are going to bounce around—ricocheting off walls, ceilings, and floors—until you're all worn out and your place is upside down. The horns are purely decorative; these little fur balls couldn't hurt anybody. Notice their closed eyes. This represents extreme joy. Then look at the chibi's wide-open eyes, representing extreme distress!

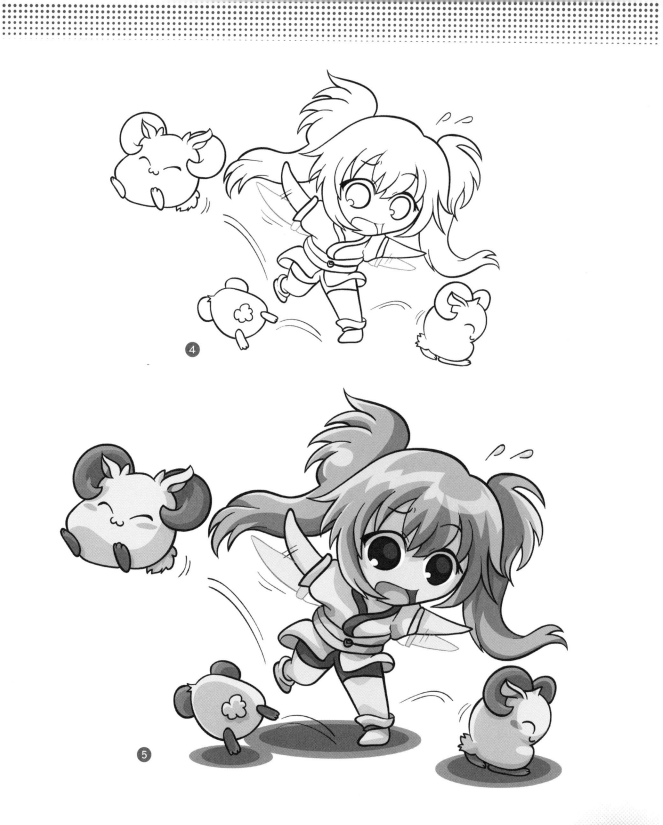

Protective Mascot

This mascot summons all his powers to protect his chibi friend from evildoers.

This mascot is a plant hybrid, a popular type of creature. You can see this in his leaf-horns and tail. He has button eyes and only a dot for a nose. His arms and legs are short and cute just as they are, so there's no need to add fingers or toes.

The chibi girl has cat ears that are drawn horizontally. Her knees and hands are together in this timid pose, as she hides from danger behind her protector-friend.

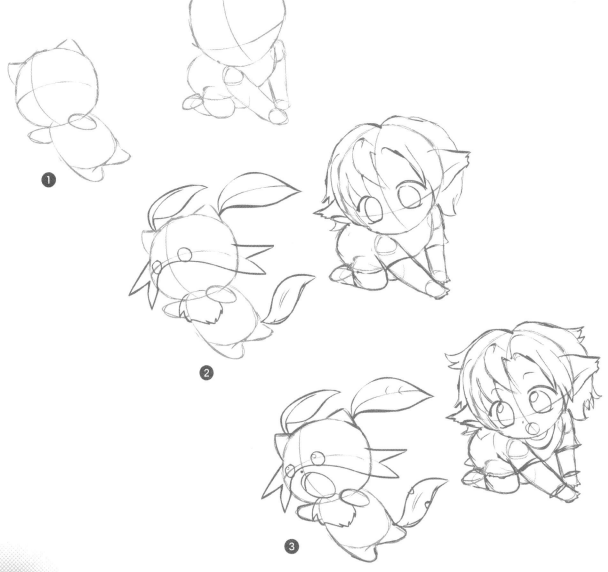

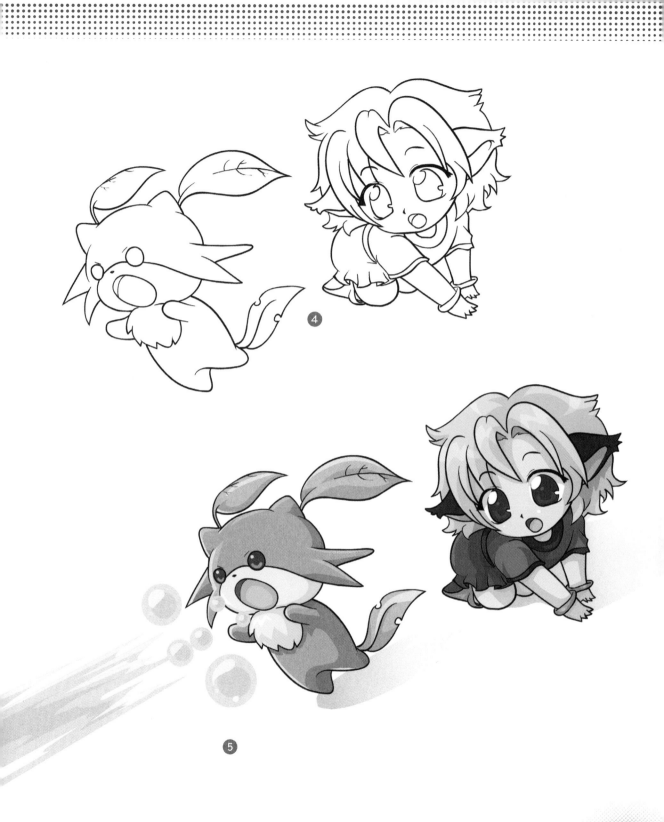

Scaredy-Cat

This kitty is going to turn his chibi into a scratching post if he's not careful. His eyes are so wide with fear that the boundaries between them are gone and they're now melded together into one. If you look closely, you'll also see little motion lines in the whites of the eyes, surrounding the pupils, in the final, color image.

In contrast to this, the boy has one eyebrow up and the other down, which is the classic expression for consternation. His hair is a mess, adding to the sense of confusion. He's also swimming in those clothes that are too big for him. But then again, everything is too big for him—he's a chibi!

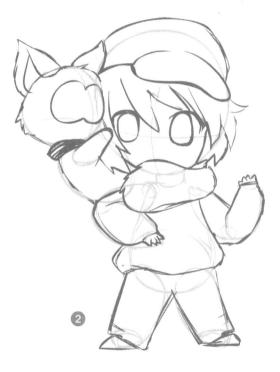

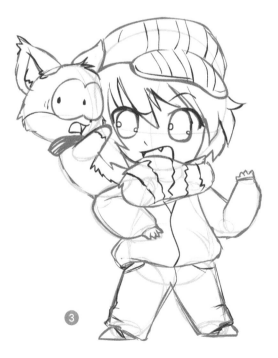

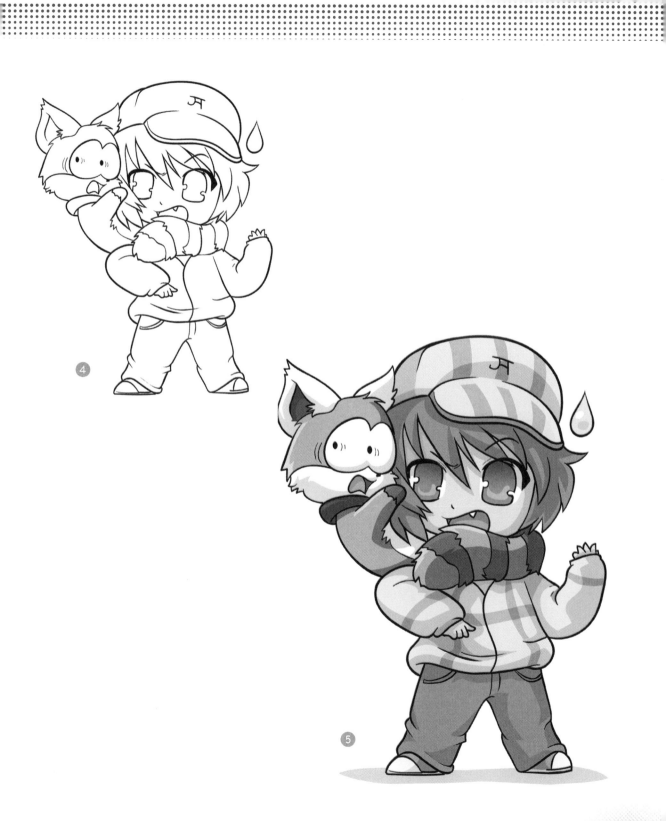

Sushi Swiper

Mini-monsters are notorious for mischief. And look at the result of this monster's brazen pilfering: He sends his chibi friend into a rage! His eyes go blank inside his glasses, blush streaks go down his cheek, and a shock effect emanates from the side of his head.

It looks as if these two characters are far apart because the mascot is so much larger than his chibi friend. But in reality, the monster's foot is almost touching the table. So they're actually in close proximity to each other. It's only an illusion that they're far apart.

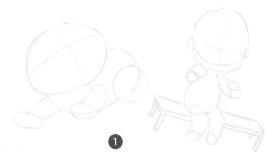

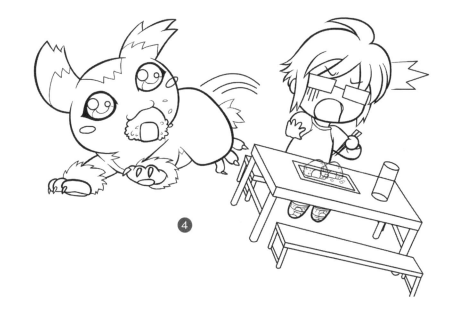

④

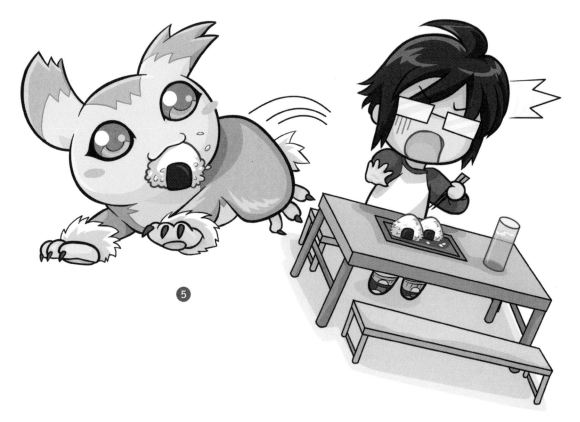

⑤

PART THREE
Let's Practice It

Now, let's see just how much you've learned. In this section, I will provide some characters—but something will be missing. It will be up to you to draw it to complete the picture. This is a great way to practice your newly formed skills, and a chance to exercise your own creative license in drawing chibi characters. It's been fun—I hope you've had as much fun as I have!

This chibi just took a spill. Can you draw his face?

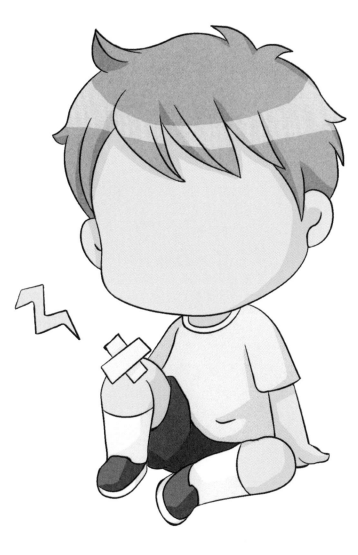

Draw this chibi's body—be sure not to make him too tall!

Can you draw the head on this chibi? Remember, her head should be larger than her body.

What kind of mascots would these two chibi characters have?

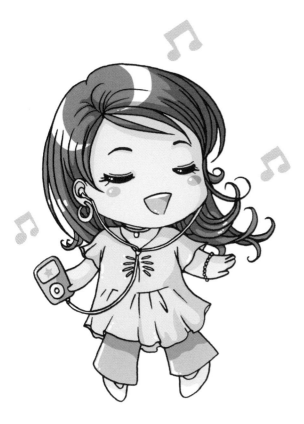

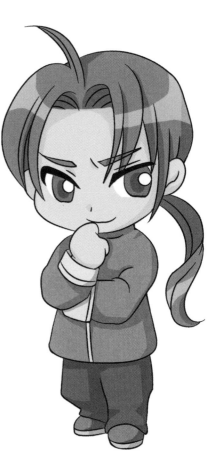

Draw this mascot's chibi friend.

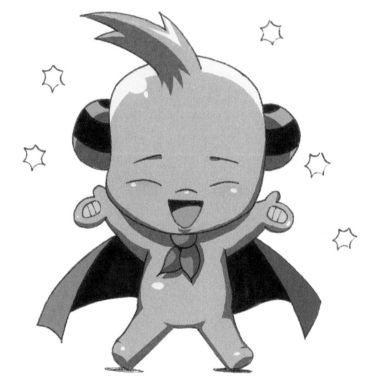

Make this chibi look very happy.

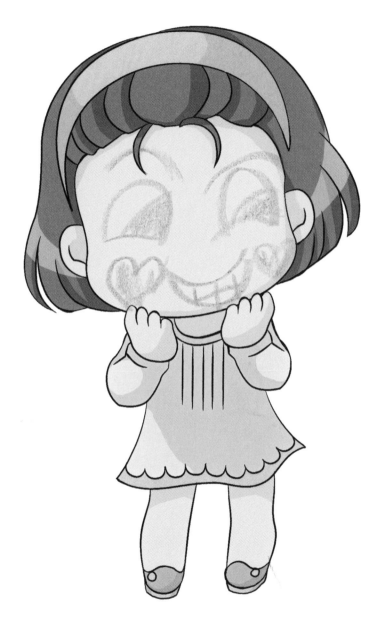

This chibi just ate something that tasted disgusting! Can you draw her expression?

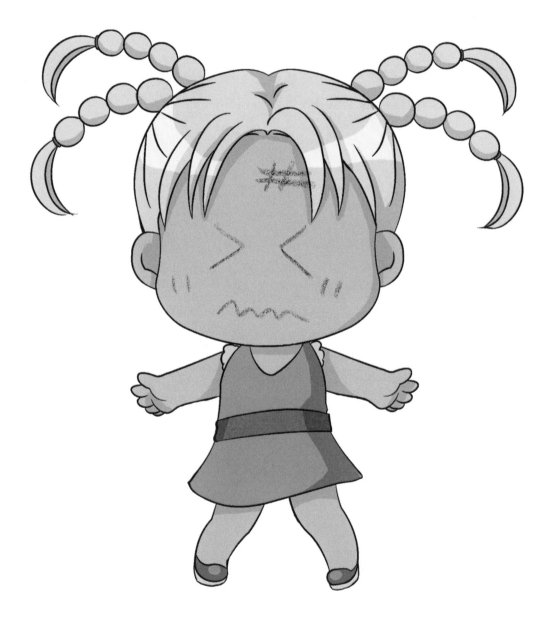

What kind of monster is this chibi running from?

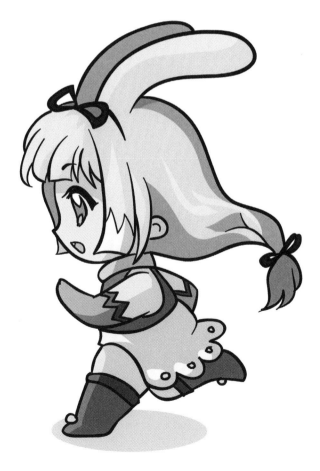

Also available in *Christopher Hart's Draw Manga Now!* series